SPOT A DOG

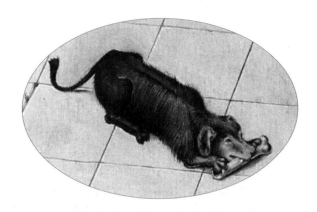

A DORLING KINDERSLEY BOOK

For Henry

First American Edition, 1995

2 4 6 8 10 9 7 5 3 1

Published in the United States by
Dorling Kindersley Publishing, Inc., 95 Madison Avenue
New York, New York 10016

Library of Congress Cataloging-in-Publication Data

Micklethwait, Lucy
 Spot a dog. — 1st American ed.
 p. cm.
 Summary: Introduces thirteen famous paintings by asking the reader to find the dog in
each one.
 ISBN 0-7894-0145-2
 1. Dogs in art—Juvenile literature. 2. Painting—Appreciation—
Juvenile literature. [1. Dogs in art. 2. Painting 3. Art
appreciation.] I. Dorling Kindersley, Inc.
ND 1380.S67 1995
750' .1'1—dc20
 94–48608
 CIP
 AC

Color reproduction by G.R.B. Graphica, Verona
Printed in Italy by L.E.G.O.

SPOT A DOG

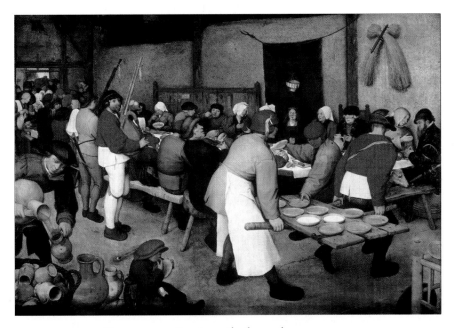

Lucy Micklethwait

DORLING KINDERSLEY
LONDON • NEW YORK • STUTTGART

I can see a big dog.

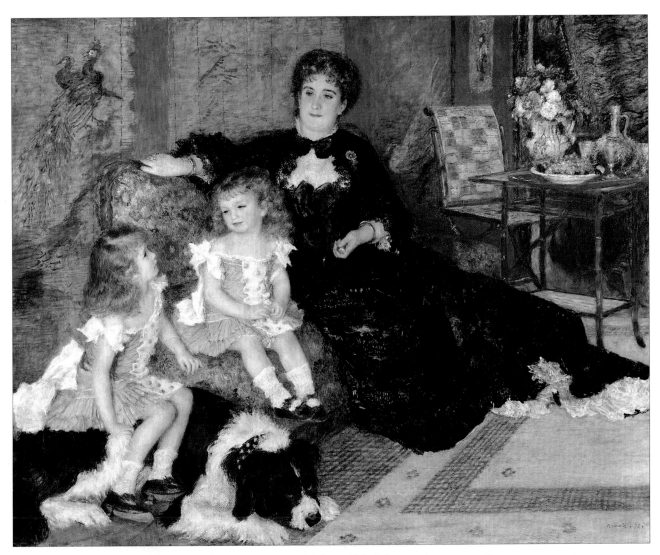

Madame Charpentier and her Children Auguste Renoir

Where is the little dog?

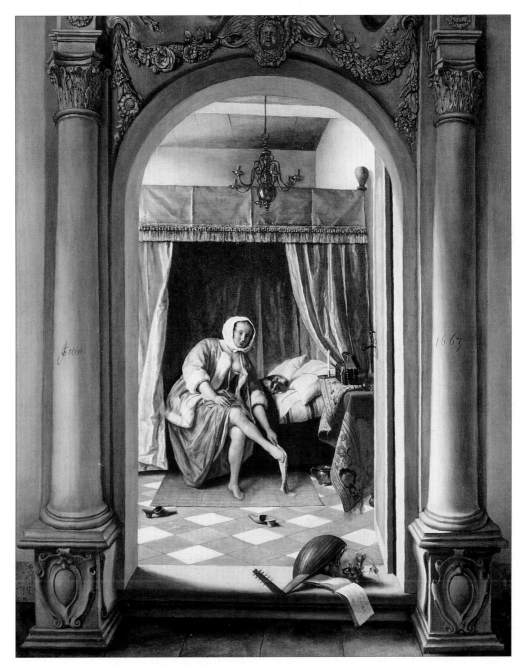

A Woman at her Toilet Jan Steen

Let's find a dappled dog.

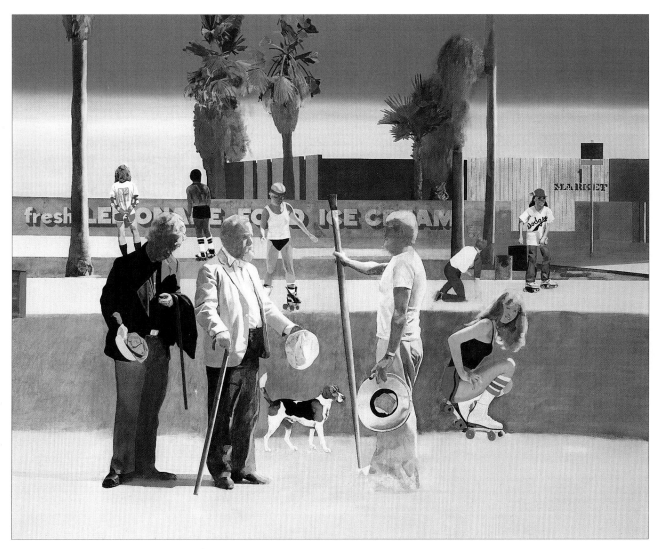

"Have a nice day, Mr. Hockney" Peter Blake

Can you
spot a dog?

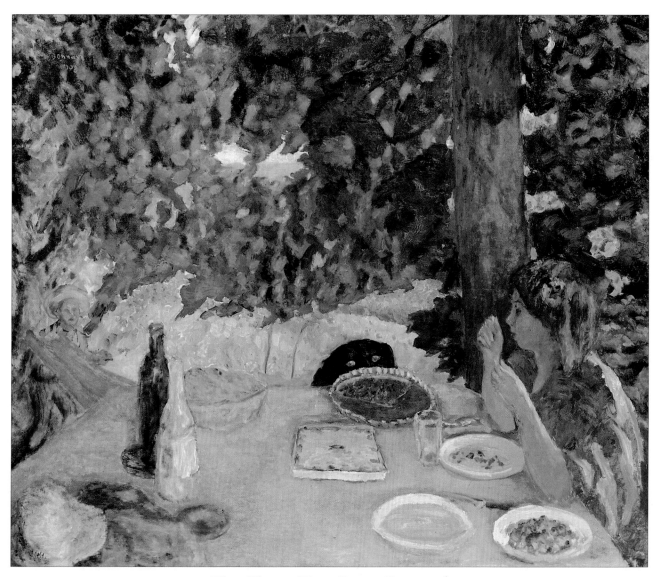

The Cherry Tart Pierre Bonnard

I can see a fluffy dog.

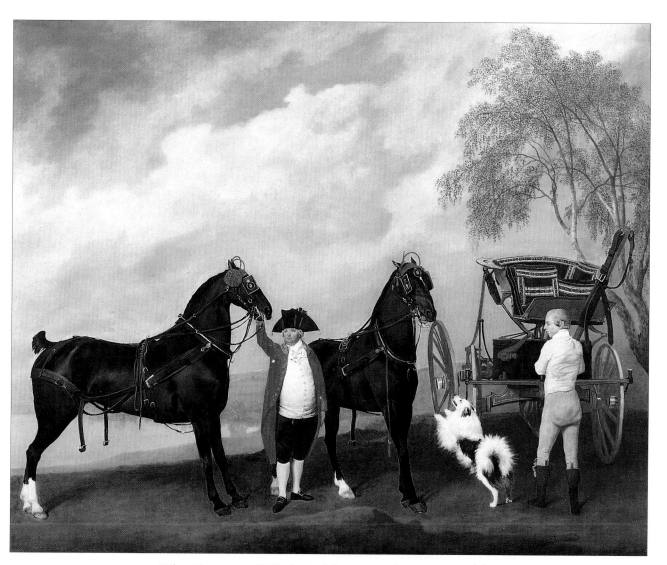

The Prince of Wales's Phaeton George Stubbs

Can you see a shy dog?

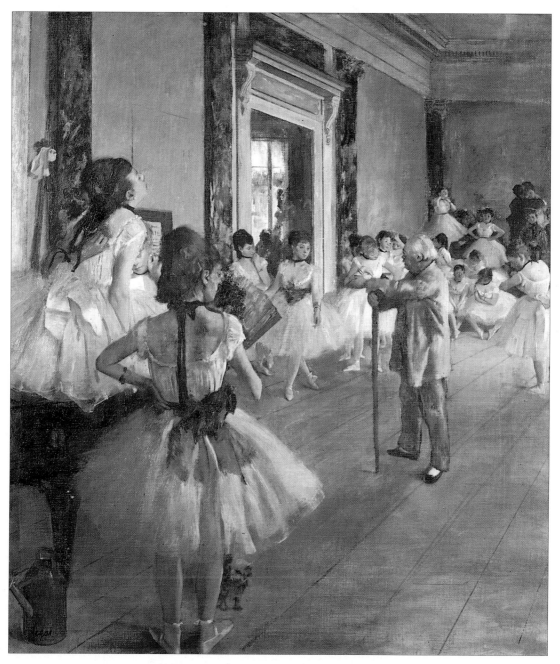

The Dancing Class Edgar Degas

Let's find a hungry dog.

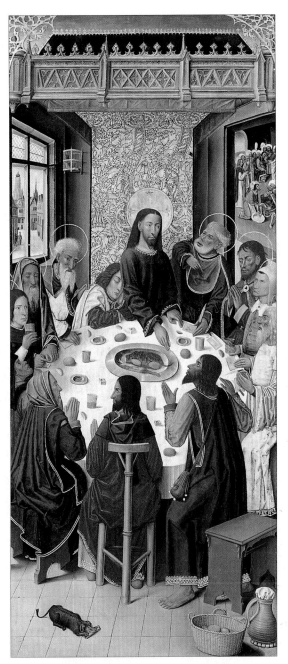

The Last Supper French

Can you
spot a dog?

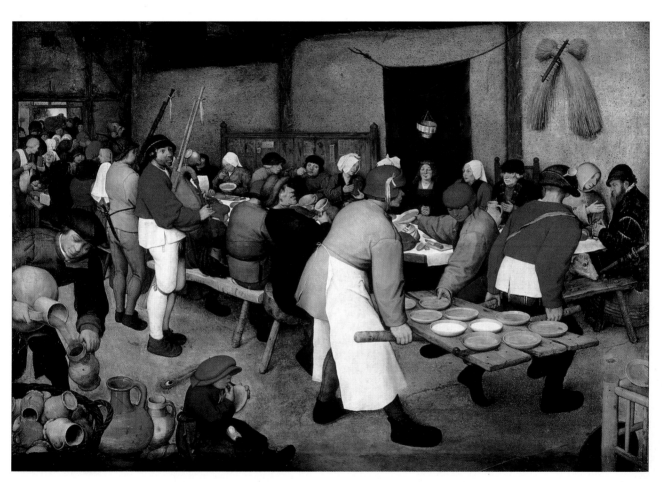

The Peasant Wedding Pieter Bruegel the Elder

I can see a black dog.

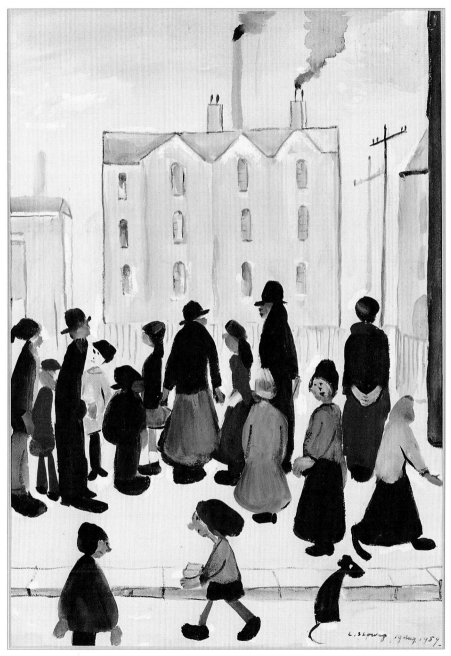

Group of People L.S. Lowry

Can you see
a white dog?

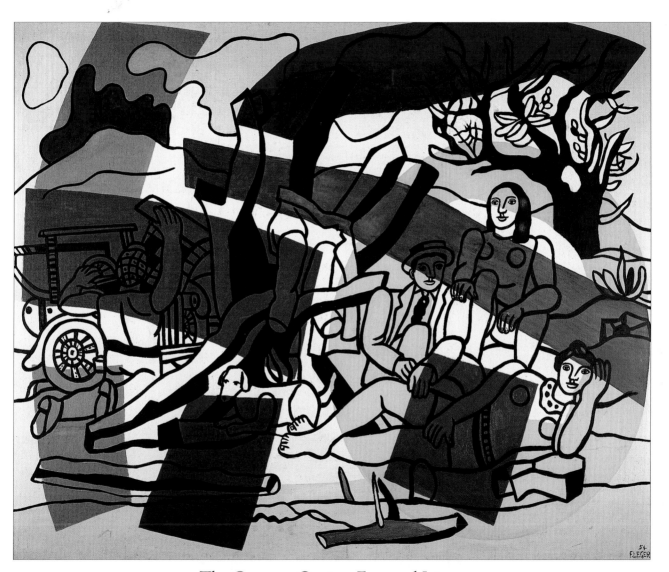

The Country Outing Fernand Léger

Let's find
a flat dog.

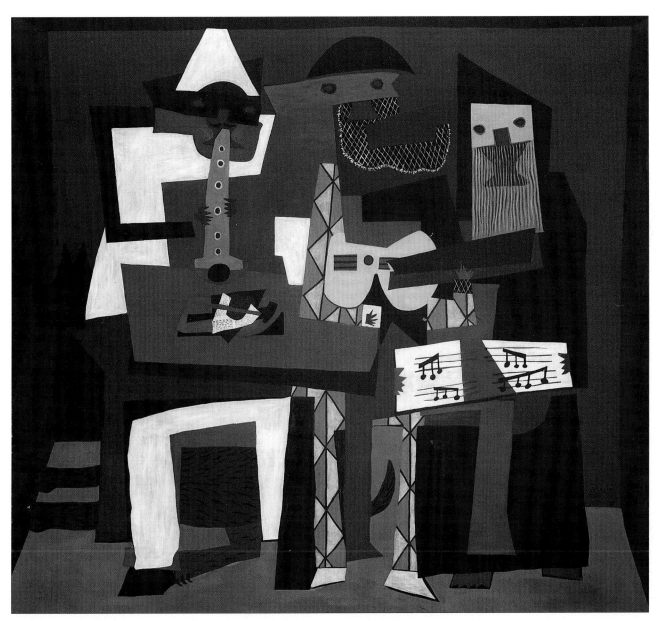

Three Musicians Pablo Picasso

Can you spot a dog?

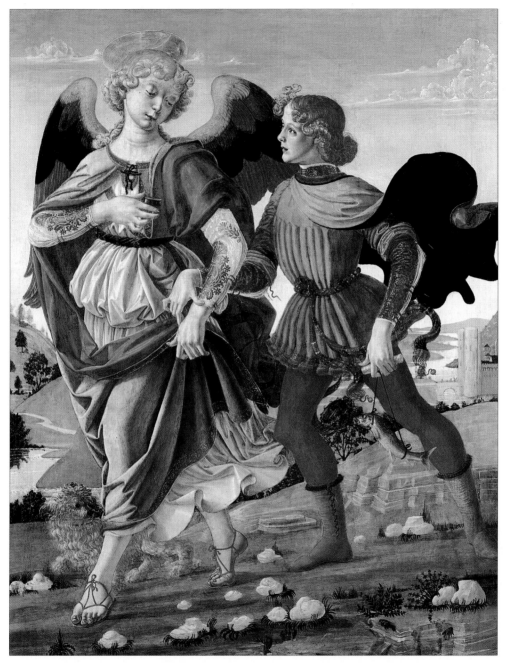

Tobias and the Angel Attributed to Andrea del Verrocchio

Here there is a big dog,
And over there a little dog,
But let's find a leopard
and a camel and a cow.
Can you spot the monkeys?
Do you see the donkey?
What shall we look for now?

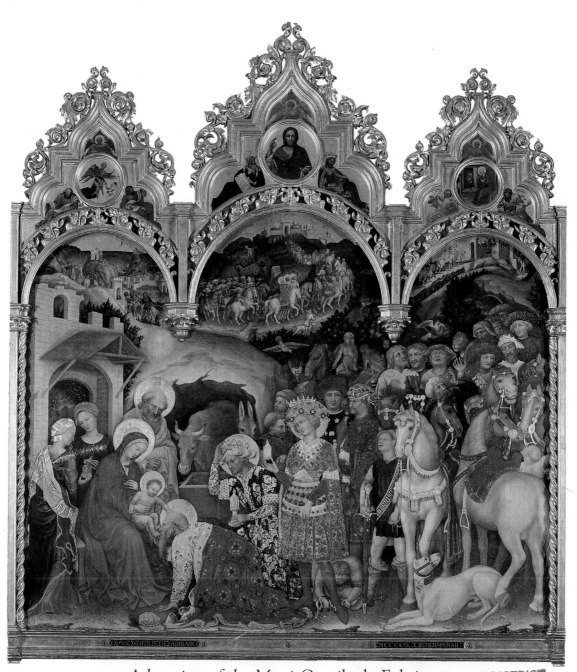

Adoration of the Magi Gentile da Fabriano

Picture List

I can see a big dog.
Auguste Renoir 1841-1919, French
Madame Charpentier and her Children 1878
oil on canvas
60$^{1}/_{2}$ x 74$^{7}/_{8}$ in (153.7 x 190.2 cm)
Metropolitan Museum of Art,
New York
Catharine Lorillard Wolfe Collection

Where is the little dog?
Jan Steen 1626-1679, Dutch
A Woman at her Toilet 1663
oil on panel
25$^{1}/_{2}$ x 20$^{7}/_{8}$ in (64.7 x 53 cm)
Royal Collection, St. James's Palace,
London

Let's find a dappled dog.
Peter Blake b. 1932, British
"Have a nice day, Mr. Hockney" 1981-85
oil on canvas
38$^{1}/_{2}$ x 48$^{3}/_{4}$ in (97.8 x 123.8 cm)
Tate Gallery, London

Can you spot a dog?
Pierre Bonnard 1867-1947, French
The Cherry Tart 1908
oil on canvas
45$^{1}/_{4}$ x 48$^{1}/_{2}$ in (115 x 123 cm)
Private Collection

I can see a fluffy dog.
George Stubbs 1724-1806, British
The Prince of Wales's Phaeton 1793
oil on canvas
40$^{1}/_{4}$ x 50$^{1}/_{2}$ in (102.2 x 128.3 cm)
Royal Collection, St. James's Palace,
London

Can you see a shy dog?
Edgar Degas 1834-1917, French
The Dancing Class 1874
oil on canvas
33$^{1}/_{2}$ x 29$^{1}/_{2}$ in (85 x 75 cm)
Musée d'Orsay, Paris

Let's find a hungry dog.
French, School of Picardie, 15th century
The Last Supper from the Thuison-
les-Abbeville Altarpiece c.1480
oil on panel
46^{1}/$_{8}$ x 20 in (117.2 x 50.9 cm)
Art Institute of Chicago
Mr. and Mrs. Martin A. Ryerson
Collection

Can you spot a dog?
Pieter Bruegel the Elder b. c.1525,
d. 1569, Netherlandish
The Peasant Wedding c.1567
oil on panel
44^{7}/$_{8}$ x 64^{1}/$_{8}$ in (114 x 163 cm)
Kunsthistorisches Museum, Vienna

I can see a black dog.
L.S. Lowry 1887-1976, British
Group of People 1959
watercolor
14 x 10 in (35.5 x 25.4 cm)
Salford Museum and Art Gallery, Salford

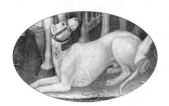

Can you see a white dog?
Fernand Léger 1881-1955, French
The Country Outing 1954
oil on canvas
96^{1}/$_{2}$ x 118^{1}/$_{8}$ in (245 x 300 cm)
Fondation Maeght, Saint-Paul

Let's find a flat dog.
Pablo Picasso 1881-1973, Spanish
Three Musicians 1921
oil on canvas
79 x 87^{3}/$_{4}$ in (200.7 x 222.9 cm)
Museum of Modern Art, New York
Mrs. Simon Guggenheim Fund

Can you spot a dog?
Attributed to Andrea del Verrocchio
c.1435-1488, Italian
Tobias and the Angel c.1470-80
tempera on wood
33 x 26 in (84 x 66 cm)
National Gallery, London

Here there is a big dog, . . .
Gentile da Fabriano c.1370-1427,
Italian
Adoration of the Magi 1423
tempera on panel
118^{1}/$_{8}$ x 111 in (300 x 282 cm)
Uffizi, Florence

Front Cover
The Cherry Tart (detail), Pierre
Bonnard
Spine
Group of People (detail), L.S. Lowry
Half Title page
The Last Supper (detail), French
Imprint page
*Madame Charpentier and her
Children* (detail), Auguste Renoir

Title page
The Peasant Wedding, Pieter Bruegel
the Elder
Picture List
The Dancing Class (detail),
Edgar Degas
Adoration of the Magi (detail),
Gentile de Fabriano

Note: Measurements are given height by width.

Acknowledgments

The publisher would like to thank the
following for their kind permission to
reproduce the photographs:

The Last Supper, Photograph © 1994, The Art Institute
of Chicago. All rights reserved: **1 (detail), 17**
The Country Outing, Fondation Maeght, Saint-Paul,
France © DACS 1995: **23**
The Peasant Wedding, Kunsthistorisches Museum,
Vienna: **3, 19**
The Dancing Class, Louvre, Paris © photo RMN: **15,
30 (detail)**
Madame Charpentier and her Children, Copyright
© 1994 by the Metropolitan Museum of Modern Art,
Wolfe Fund, 1907: **2 (detail), 5**
Three Musicians, Fontainebleau, Summer 1921,
Photograph © 1995 The Museum of Modern Art, New
York © DACS 1995: **25**

Group of People, City of Salford Museums and Art
Gallery, Salford © Lowry estate: **spine (detail), 21**
Tobias and the Angel, The National Gallery, London: **27**
The Cherry Tart, Private Collection © ADAGP/
SPADEM, Paris and DACS, London 1995: **front cover
(detail), 11**
A Woman at her Toilet, The Royal Collection © Her
Majesty Queen Elizabeth II: **7**
The Prince of Wales's Phaeton, The Royal Collection
© Her Majesty Queen Elizabeth II: **13**
"Have a nice day, Mr. Hockney," The Tate Gallery,
London © Peter Blake: **9**
Adoration of the Magi, Uffizi, Florence. Photo
SCALA: **29, 31 (detail)**